BEVERLY MASSACHUSETTS

illustration school:
let's draw cute animals

sachiko umoto

QUARRY BOOKS

Quarto is the authority on a wide range of topics.

Quarto educates, entertains and enriches the lives of
our readers—enthusiasts and lovers of hands-on living.

www.QuartoKnows.com

First published in the United States of America in 2010 by
Quarry Books, an imprint of
Quarto Publishing Group USA Inc.
100 Cummings Center
Suite 406-L
Beverly, Massachusetts 01915-6101
Telephone: (978) 282-9590
Fax: (978) 283-2742
www.QuartoKnows.com
Visit our blogs at www.QuartoKnows.com

Library of Congress Cataloging-in-Publication Data available

ISBN-13: 978-1-59253-645-0
ISBN-10: 1-59253-645-X

21

Printed in China

to the reader

They say that "learning" begins by "imitating," so I have filled this book with a lot of illustrations that you can draw by copying. Take your time, look at each illustration one by one, then choose one you like and try tracing or drawing one yourself. Your drawing doesn't have to turn out just like the example, so don't worry if it doesn't turn out exactly the same. Think about how you would draw the picture and arrange its parts any which way you choose!

The trick to enjoying illustration is showing your work to other people. "Don't you think this is cute?" "This is really funny-looking, isn't it?"

Ask your family and friends these questions when you show them your drawings. If even a little bit of what you wanted to express gets across to them each time you show them a drawing, there is no doubt that illustrating will become more and more fun.

Work at your own pace, when you want, where you want. But whatever you do, try your hand at creating a whole bunch of really cute drawings, OK?

Sachiko Umoto

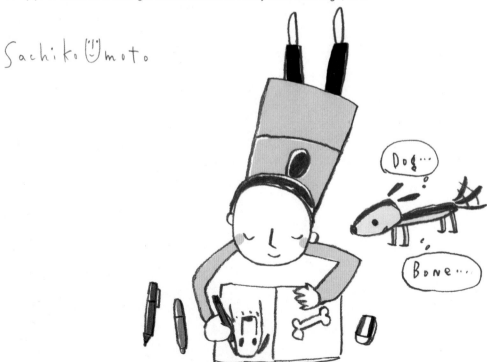

how to enjoy this book

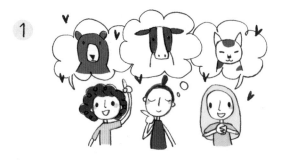

choose one

Look for your favorite character. Ask your friends and family what characters they like.

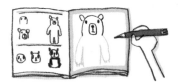
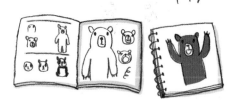

imitate it

Look at the page on the left and use the guide to casually trace what you see.

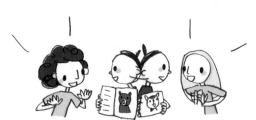

modify it

Try changing the expression of your drawing. You can make different poses, or add different colors.

show it

Show your friends and family the pages you have doodled on, or the notebooks and memo pads you have drawn on.

Pencils and Mechanical Pens

If you make a mistake, you can just erase it, so you can draw anything in any way you choose. Apply different pressures to your pencil tip to get a diverse array of lines

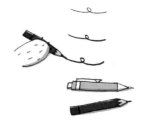

Erasers

Your eraser is a reliable friend you can always count on. Its edges will start to get round as you use it, but that's OK! Simply use a craft knife to carve sharper corners.

Erase with the edges.

Erase a little more than you need to and draw what you lost.

The lines you should erase with your eraser are shown using dotted lines.

Ballpoint Pens and Felt-Tipped Markers

Try drawing the entire picture at once. You won't be able to erase your mistakes, but you can draw things pretty quickly.

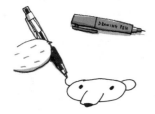

Colored Pencils and Colored Felt-Tipped Markers

Coloring can also be a lot of fun. You don't have to color the entire picture. Leave some white space. Wrapping up your drawing with just a few colors can add a really nice finish.

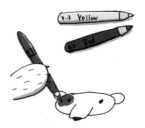

Notebooks, Appointment Books, Memo Pads, Etc.

You can use whatever you can find around you for your canvas. I recommend doodling, as long as your doodles don't interfere with your studies or your work.

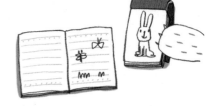

the basics of the basics

Learning some basic skills helps make drawing easy. But, remember, the basics are nothing more than a fundamental starting point.

1. Draw larger shapes first

Draw the head before you draw the eyes or the nose, draw the body before you draw the hands, feet, or other patterns. Try to get an idea of the overall shape before you add the fine details.

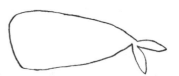

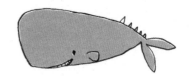

2. Draw from top to bottom, right to left

Pick up your pen or pencil and try waving it around. Can you feel how natural it is to move it from top to bottom or right to left? (Or left to right, if you are left-handed!)

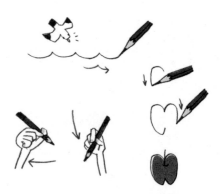

This hedgehog looks so friendly he could be walking down any street.

3. Draw the head before you draw the body

When you draw the head, you can get a feel for your animal's personality and what it is probably thinking at the time. This makes it easier for you to decide how to draw the rest of the body

The Basics Can Be Contradictory

Sometimes the basics described in steps 1, 2 and 3 will seem to contradict each other, and you may have a hard time deciding where to start. If that is the case, just start wherever you want.

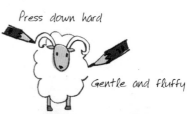

After drawing the wiggly shape, draw the face

After drawing the face, add color to the body

4. Apply different pressures to the tip of your pen

Press hard when you draw the solid parts and lightly when you draw the soft parts. You can draw a lot of different lines with the same pen just by applying different amounts of pressure.

Press down hard

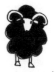

Gentle and fluffy

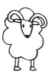

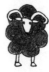

Leave uncolored

Gently shade with gray

Color in strong black

illustration school with cute animals

contents

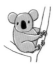

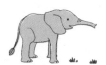

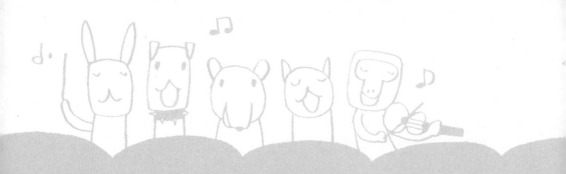

prologue: drawing songs

Singing while you draw can help you draw brisk lines.

rabi, the rabbit song

kumapon, the bear song

the doggie song

saruzo, the monkey song

nyanta, the cat song

rabi, the rabbit song

 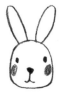

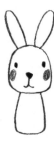 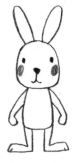

♪1

Raisins, I found three
(Draw the shape of the
face and some black
round dots for the eyes
and nose.)

♪2

**I carve a few lines
in my bread**
(Draw lines that extend
to and connect the
mouth and nose.)

♪3

**Fresh rolls baked
golden brown**
(Draw the ears tilting
sideways from the center
of the top of the head.)

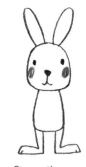

♪4

**One loaf of sandwich
bread hot out of the oven**
(Draw a long, slim body.)

♪5

**Stomp the ground
with my feet**
(Draw legs with large feet.)

♪6

**Double your fingers
and clench your fists**
(Draw the arms extending
from both sides of the body.)

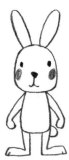 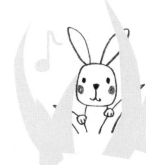

♪7

I see your tail, you're Rabi the Rabbit
(Once you've drawn the tail, you are done!)

let's draw!

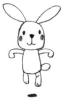

Jump! Zzzzz Munch Hmnnn long, hard stare Thump, thump, thump

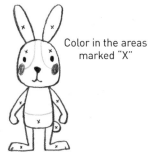

Color in the areas marked "X"

Pandarabi, I found you! Droopy Ear Rabbit, I found you! Rabi Rabbit, there you are!

kumapon, the bear song

♪1
**A big dumpling,
just a little pull**
(Draw the shape of the face
and the protruding nose.)

♪2
**Add three beans
and clean up a little**
(Draw black dots for the
eyes, the tip of the nose,
and erase the extra line.)

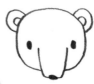

♪3
**Stick on doughnuts, a
half on each side**
(Draw two double half
circles for the ears.)

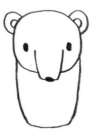

♪4
Add a plump rice cake
(Draw a squat body.)

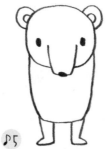

♪5
I found a pair of boots
(Draw the stubby
toes and the legs.)

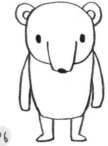

♪6
Stretch out the rice cakes
(Draw the arms extending
from both sides of the body.)

♪7
**I see your tail, Kumapon
Bear! He's coming
out of the woods!**
(Once you've drawn the
tail, you are done!)

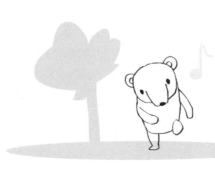

let's draw!

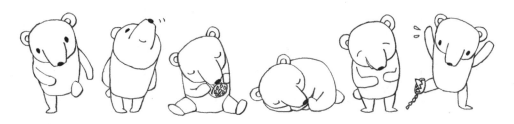

| Step, step | Sniff, sniff | Munch, munch | Zzzzz | Ha, ha, ha | Eeyow! |

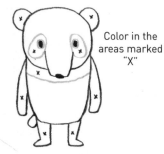

Color in the
areas marked
"X"

Pandapon Bear's here, too!

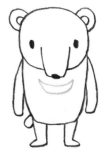

And Crescent Moon Bear, too!

the doggie song

 ♪1

A block of tofu and
two sesame seeds
(Draw the square
face and the eyes.)

 ♪2

Add a little soy sauce,
mmmm... so delicious
(Draw lines that
extend to and connect
the mouth and nose.)

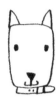 **♪3**

Stick on some triangles
of steamed fish
(Draw two triangular
ears and the doggie collar.)

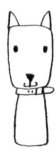 **♪4**

Add another block of tofu
(Draw a sharp, slim body.)

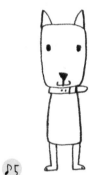 **♪5**

Add on two steamed
fish sausages
(Draw sturdy legs
and toes.)

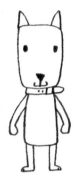 **♪6**

Another helping of fish
sausage, please
(Draw the arms extending
from both sides of the body.)

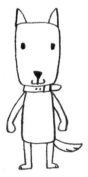 **♪7**

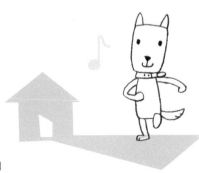

Here comes Doggie wagging his tail!
(Once you've added the tail, you are done!)

let's draw!

Give me your paw.

Munch, munch, munch

Going for a walk

Sit, boy, sit.

Catch!

Yeah!

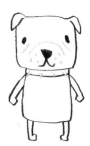

Mister Bull on the scene!

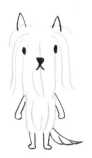

Bushy haired

And here's Doggie!

Miss Moja has arrived!

saruzo, the monkey song

♪1

The square rice cake has gotten puffy
(Draw the face and protruding nose.)

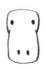

♪2

Add two beans on the top, two on the bottom
(Draw the eyes and nostrils.)

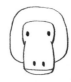

♪3

Lay another rice cake on top of the first
(Draw the head and a coat of fur.)

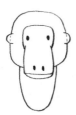

♪4

This one gets more and more puffy, too
(Draw the ears and the body.)

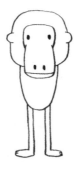

♪5

And it stretches and stretches...
(Draw the legs and toes.)

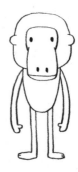

♪6

And it keeps stretching and stretching...
(Draw the arms extending from both sides of the body.)

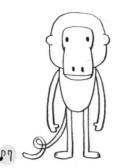

♪7

Here comes mischievous Saruzo with his curly tail!
(Once you've added the tail, you are done!)

let's draw!

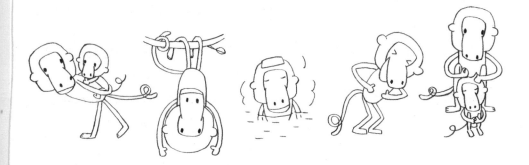

Piggyback ride Hanging This hot bath is heaven! Ha, ha, ha Grooming

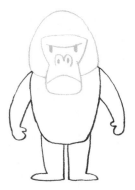

Gorisuke looks really strong!

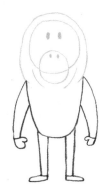

Oranguko seems really gentle!

Naughty little Saruzo is here!

nyanta, the cat song

♪1
**I poked some holes
in a bean-jam bun**
(Draw the face, the eyes,
and the lines of the nose.)

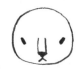

♪2
**Bean-jam oozes
outside from the inside**
(Draw the nose and
mouth.)

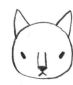

♪3
**Start with a bite of the
tasty crust**
(Draw the triangular
ears.)

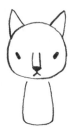

♪4
**Plump and round, my
tummy's full**
(Draw a round, soft body.)

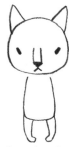

♪5
**Creeping along
on tippy-toes**
(Draw the rounded legs
and small paws.)

♪6
**Clench the pads on both
hands into fists**
(Draw the arms
extending from both sides
of the body.)

♪7
**Look, there's Nyanta saying
"hi" with a wave of his tail!**
(Once you've added the tail,
you are done!)

let's draw!

Stretch

Phew!

Flip-flop

Jump!

Quick step

Washing his face

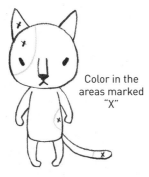

Look, there's Mikenekomi,
the Calico cat!

Color in the
areas marked
"X"

And there's Jiro,
the striped cat!

And Nyanta, too!

drawing diverse facial expressions

Thinking about what your character may be feeling as you draw a variety of facial expressions can help you create fun illustrations. Let's try it!

diverse animal expressions

Front views

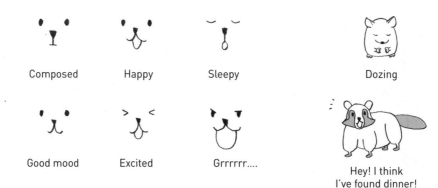

Composed Happy Sleepy Dozing

Good mood Excited Grrrrrr....

Hey! I think
I've found dinner!

Side views

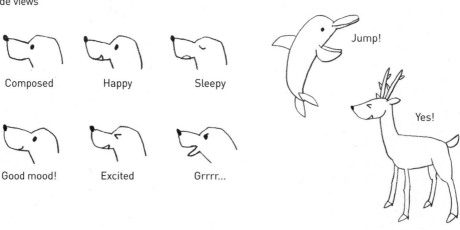

Composed Happy Sleepy

Good mood! Excited Grrrr...

Jump!

Yes!

diverse animal expressions (bills)

Front views

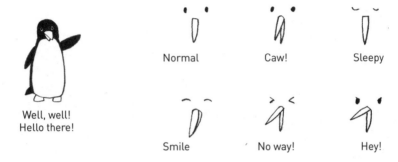

Well, well!
Hello there!

Normal

Caw!

Sleepy

Smile

No way!

Hey!

Side views

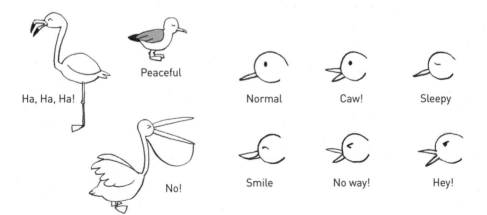

Peaceful

Ha, Ha, Ha!

No!

Normal

Caw!

Sleepy

Smile

No way!

Hey!

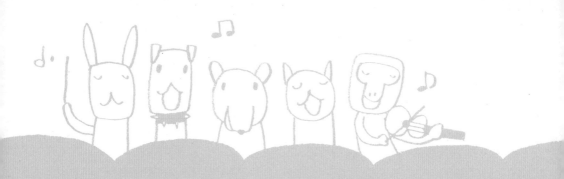

chapter | life in the woods

the animals that live in the fertile woods conduct lifestyles that are gentle on the environment

bears / pandas

Japanese racoons / racoons

urangutans / Japanese monkeys

horses / donkeys

deer / reindeer

wolves / foxes

kangaroos / koalas

ducks / platypuses

cows / buffaloes

pigs / wild boar

goats / sheep

porcupines / moles

flying squirrels / squirrels

rabbits / capybara

bears

Bears eat more than just meat. they also love insects, sprouting grasses, and honey.

His head is slightly tilted.

His ears extend in line with his nose and eyes.

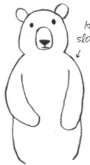

He has rather sloping shoulders.

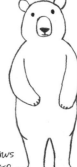

His claws are sharp.

1. Draw the head, eyes, nose, ears and mouth.

2. Draw a rounded, heavy-looking body and arms.

3. Finish by drawing strong legs and sharp claws.

pandas

Their diet consists mainly of bamboo. They have black and white fur, but their tails are white.

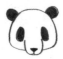

Their heads and cheeks are round.

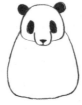

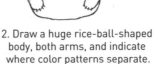

Their shoulders are draped in black

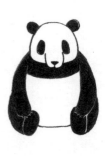

1. Draw the rice-ball-shaped head, droopy eyes and nose, and the ears.

2. Draw a huge rice-ball-shaped body, both arms, and indicate where color patterns separate.

3. Draw both legs and color in the pattern.

let's draw!

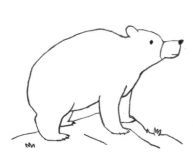

Let's draw a bear.

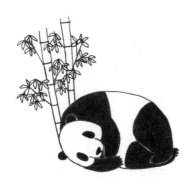

Let's draw a panda.

Japanese raccoons

The term "playing possum" comes from the way raccoons faint in surprise when they hear the sound of a gunshot.

The nose and chin should be round; so should the ears.

1. Draw the head, eyes, nose, ears and the facial pattern.

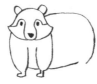

2. Draw the forelegs and a short and dumpy body.

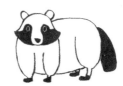

Their fore and hind legs and their bodies are pudgy.

3. Draw the hind legs and tail, and finish up by coloring it in.

raccoons

Though they are well-known for how they wash their food before they eat it, this is not true of all raccoons.

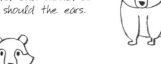

Make the ears pointy.

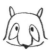

They have shadows that surround the eyes.

1. Draw the head, eyes, nose, ears, and the patterns that surround the eyes. .

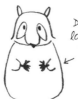

Draw dexterous-looking hands and fingers.

2. Draw the front paws (Don't forget the nimble-looking fingers and the body.)

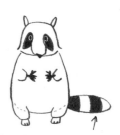

They have a unique stripe pattern on their tails.

3. Draw the back legs and tail, and finish up by coloring in the patterns!

let's draw!

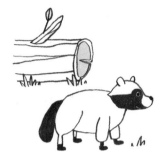

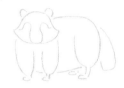

Let's draw a Japanese Raccoon.

Color the tail, the patterns surrounding the eyes, and the feet black

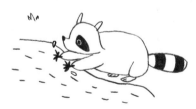

Let's draw a raccoon.

orangutans

In the Malay language, the name "orangutan" means "forest people." They live in the treetops.

Draw two overlapping circles so that the top circle is bigger than the bottom one.

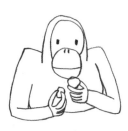

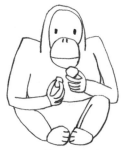

Draw the long legs in a folded position.

1. Draw a wide forehead, a big chin, the eyes, nose, and mouth.

2. Now draw two long arms and a broad chest.

3. Draw folded legs.

Japanese monkeys

Of all the monkeys in the world, these monkeys are rare for their ability to withstand the cold.

Their faces are shaped like mushrooms.

The palms of their hands and the soles of their feet are long.

1. Draw the face and a long nose, the eyes, mouth, and head.

2. Draw the back, chest, and bottom. Japanese monkeys have short tails.

3. Finish up by drawing the arms, hands, legs and feet, and a red bottom!

let's draw!

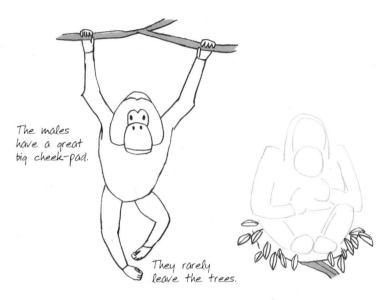

The males have a great big cheek-pad.

They rarely leave the trees.

Let's draw an orangutan.

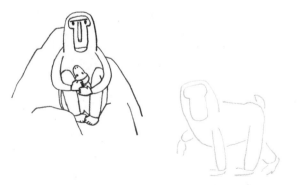

Let's draw a Japanese monkey.

horses

These gentle and friendly animals have sensitive personalities and value their relationships of trust with human beings.

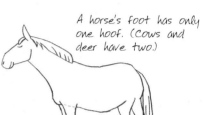

Horses are square-jawed.

They have boney, thick stomachs, backs, and bottoms.

A horse's foot has only one hoof. (Cows and deer have two.)

1. Draw the head, ears, neck, eyes, nose, and mane.

2. Draw a burly body.

3. Draw strong legs and hoofs and a fluffy tail.

donkeys

Donkeys have great memories and are very strong. their ears are adorable and big.

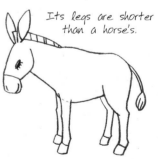

The color pattern changes here.

Big ears and big eyes are their trademark

Its body slopes downward from its neck to its bottom.

Its legs are shorter than a horse's.

1. Draw a large head, eyes, nose, and mouth.

2. Draw the back, bottom, chest, and mane.

3. Draw slightly short legs and a tail.

let's draw!

The horse's back does not curve when it gallops, making it perfect for riding!

Let's draw a horse.

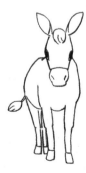

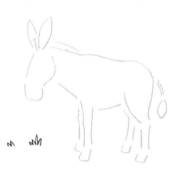

Let's draw a donkey.

Donkeys can remember the way back and forth over a span of a few kilometers.

deer

Only the male deer has antlers. They are shed and grow back every year and become more stately with age.

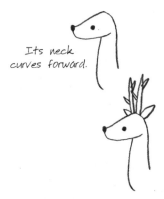

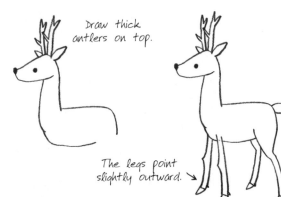

Its neck curves forward.

Draw thick antlers on top.

The legs point slightly outward. →

1. Draw the head and a long, shapely neck, eyes, nose, and ears. On top of it all, draw antlers.

2. Draw the back, bottom, and chest.

3. Draw long-hoofed legs and a short tail.

reindeer

Both males and females have antlers, which are shed every year in the winter by the male, and in the spring by the female.

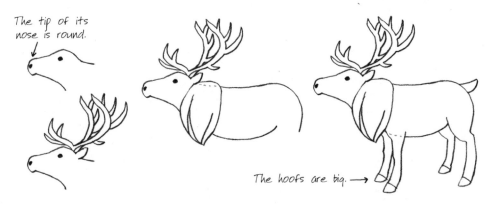

The tip of its nose is round.

The hoofs are big. →

1. Draw the head, eyes, nose, ears, and the expansive antlers.

2. Draw a luxuriant muffler-like mane and the back, buttocks, and stomach.

3. Draw its thick legs, hooves, and the short tail.

let's draw!

When it is surprised, its
tail hair turns upward.

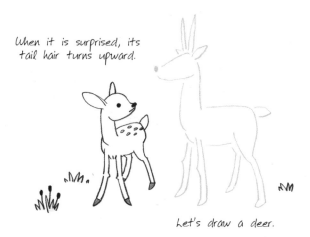

Let's draw a deer.

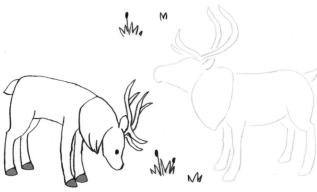

Reindeer are the only animals whose
female counterparts grow antlers.

Let's draw a reindeer.

wolves

Wolves live in packs, so they develop and use their voices, behaviors, and a diverse array of other means of communication.

Draw the nose first.

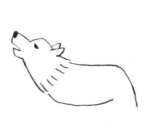

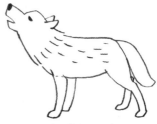

Its legs and paws are also powerful.

1. Start by drawing the nose, mouth, head, ears, and the fur around its neck.

2. Draw its back, buttocks, chest, and stomach.

3. Draw strong legs, a thick tail and bushy fur.

foxes

A fox born in the spring will be ready to venture out on its own by autumn. They prefer to live alone, not in packs.

They have triangular eyes and nose.

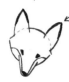

Their ears are also triangular and black-tipped.

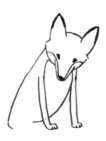

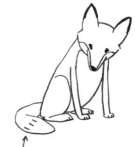

The thick tail sets it apart from a dog.

1. Draw the head with triangular eyes, a pointy nose, piqued ears, and the color pattern.

2. Draw its forelegs, back, and stomach.

3. Draw its hind legs and a thick tail.

let's draw!

It uses its howl to
communicate with its companions.

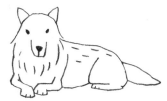

To let them know it is alone.
Or to assert its domain.

Let's draw a wolf.

The further north the habitat of
the fox, the shorter its ears grow.

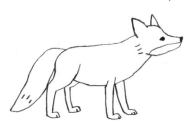

Let's draw a fox.

kangaroos

Kangaroos raise their young in their stomach pouches. Newborn cubs will find their own ways into their mother's pouch.

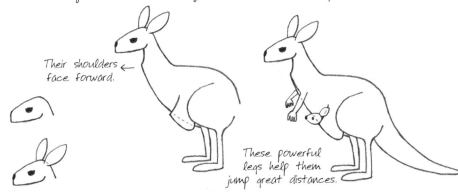

Their shoulders face forward.

These powerful legs help them jump great distances.

1. First, draw the nose, head, triangular eyes and ears.

2. Draw a big body and powerful hind legs and a stomach with a pocket.

3. Finish by drawing the forelegs and tail, and a baby kangaroo in its pouch!

koalas

Since its main diet of eucalyptus leaves does not provide much nourishment, to conserve energy it spends most of its time sleeping.

Large round ears and nose are their most distinctive features.

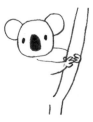

They hold on tightly with their tiny hands.

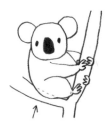

They have no tails.

1. Draw a round head and ears, a large nose, and eyes.

2. Draw forelegs holding tightly to a branch and the branch itself.

3. Draw the hind legs tightly gripping the branch, its buttocks, and the branch it is perched on.

let's draw!

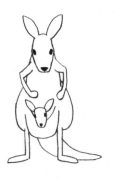

Want to box?

Let's draw a kangaroo.

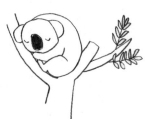

He spends most of
his life in a tree.

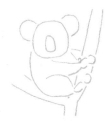

Let's draw a koala.

ducks

This strain of duck is not originally from the wild.
It was cultivated from wild ducks as domestic poultry.

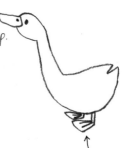

The bill curves upward.

Its buttocks sticks up.

The stomach is really round.

Add the legs just to the rear of the center of the body.

1. Draw the head, bill, and eyes.

2. Draw a long neck, the back, buttocks, and stomach.

3. Add webbing to the feet.

platypuses

These curious mammals are born from eggs. They are
said to have been around since the time of the dinosaur.

The bill is flat.

They have webbed feet.

1. Draw the head, a flat bill, eyes, and the nostrils.

2. Draw a short and dumpy body, its buttocks, and its stomach.

3. Draw the webbed feet.

let's draw!

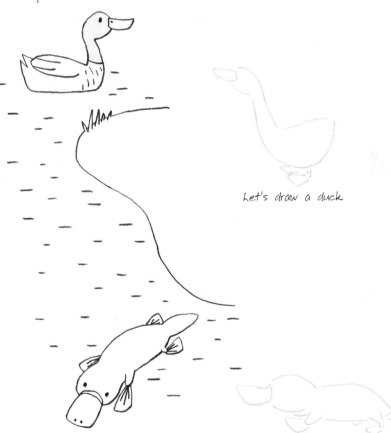

Japanese mallard duck

Let's draw a duck

Searching for its dinner in the water

Let's draw a platypus.

Cows have four stomachs. To help their digestion,
they regurgitate and rechew their food.

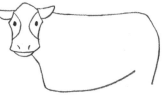

Draw any pattern you like.

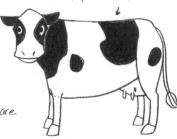

Their chins and the sides
of their eyes protrude.

The chest and buttocks are square.

1. Draw the head, eyes and
nose, the ears, mouth, and
the facial pattern.

2. Draw the back, buttocks,
chest, stomach , and a
square body.

3. Draw the feet and hoofs,
the udders and tail, and color
in the patterns.

buffaloes

These animals are also known as American buffalo. Despite their huge
bodies, they can reach speeds of up to 37 mph (60 kmh).

Their mufflers are
fluffy and their
shoulders protrude.

The buttocks is lower
than the shoulders.

Their faces
are slightly
drooping.

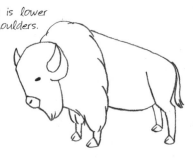

1. Draw a square forehead,
a round nose, the eyes,
and the horns.

2. Draw the protruding
shoulders, a fluffy muffler,
and drooping buttocks.

3. Draw powerful legs and
hoofs and the tail.

let's draw!

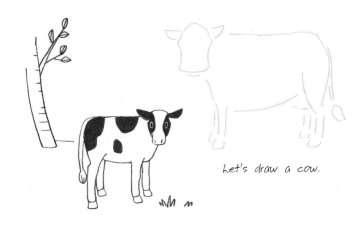

Let's draw a cow.

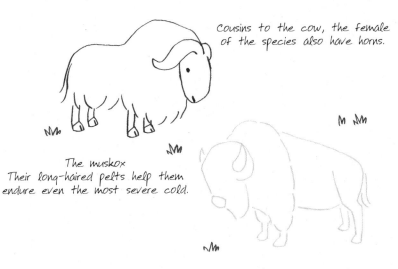

Cousins to the cow, the female of the species also have horns.

The muskox
Their long-haired pelts help them endure even the most severe cold.

Let's draw a buffalo.

pigs

Pigs were domesticated from the wild boar. It is said that they will often revert to their ancestral wild boar traits when returned to the wild.

The tail is curly.

The chest and stomach are round.

Their cleft toes are scissorlike.

1. Draw the head and nose, the ears, and mouth.

2. Draw the back and stomach.

3. Draw the feet and cleft, scissorlike hoofs, and the tail.

wild boar

their noses are really powerful, and they use them to dig in the soil in search of food.

Their eyes lie in a direct line that connects the nose and ears.

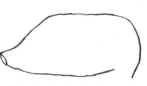

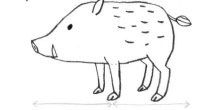

The back is stocky and the stomach is flat.

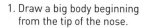

Their forelegs attach around the middle of the body.

1. Draw a big body beginning from the tip of the nose.

2. Draw the eyes, ears, tusks, and nostrils.

3. Draw the feet and cleft, scissorlike hoofs, and the tail.

let's draw!

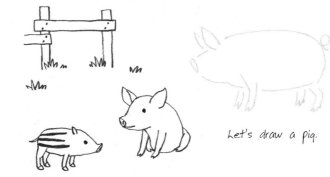

Let's draw a pig.

Uribow, a baby wild boar

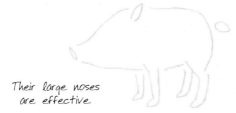

Their large noses are effective.

Let's draw a wild boar.

goats

Did you know that the famous luxury yarns known as angora and cashmere are both types of goat wool?

Their ears are situated to left and right sides of their heads and their horns grow upright.

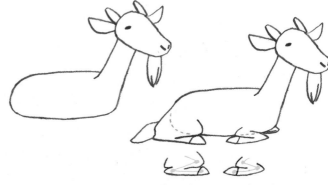

Their legs fold like this.

1. Draw the head, eyes and nose, the ears, horns, and beard.

2. Draw a long neck and body.

3. Draw folded feet and the tail.

sheep

Sheep's wool is highly heat- and moisture-retentive, and it is easily dyed, two very convenient traits.

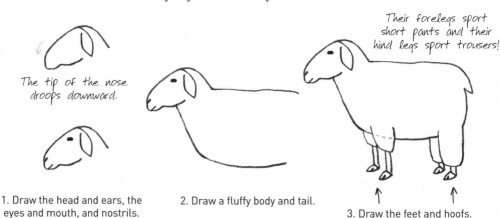

The tip of the nose droops downward.

Their forelegs sport short pants and their hind legs sport trousers!

1. Draw the head and ears, the eyes and mouth, and nostrils.

2. Draw a fluffy body and tail.

3. Draw the feet and hoofs.

let's draw!

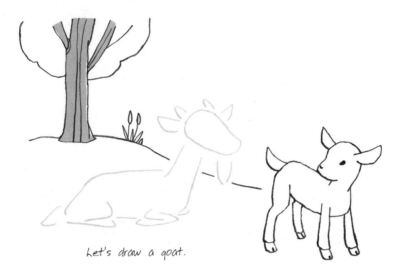

Let's draw a goat.

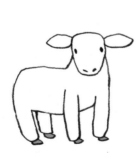

With their wide field of vision they can even see behind them.

Let's draw a sheep.

porcupines

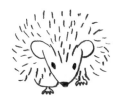

Porcupines are related to moles, not rodents. They dig and reside in nest holes in the earth.

Their needles are actually several strands of hair that come together to form hardened prickly points.

Draw some cool-looking forelocks.

Use a strong pencil stroke to give the needles a hard look

1. Draw the nose, ears, eyes, and the hair on the forehead.

2. Press hard on your drawing utensil to render the needles.

3. Draw their little feet.

moles

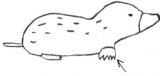

Their forelegs grow large so that they can dig holes in the earth, and their vestigial eyes enable them to live underground.

The nose

Small eyes

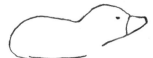

Their forelegs attach to the sides of their bodies.

1. Draw a pointy nose, the head, and the eyes.

2. Draw a rounded back and a flat stomach.

3. Draw the legs, tail, and body hair.

let's draw!

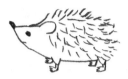

Let's draw a porcupine.

A mole hill

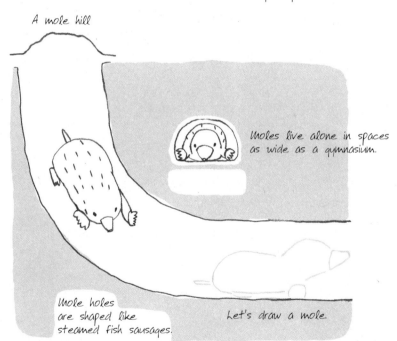

Moles live alone in spaces as wide as a gymnasium.

Mole holes are shaped like steamed fish sausages.

Let's draw a mole.

flying squirrels

They gather great amounts of nuts to have them available through the autumn and winter months, but sometimes they forget where they've stored them.

They have large eyes.

Draw their faces facing in the direction they will fly.

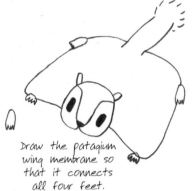

Draw the patagium wing membrane so that it connects all four feet.

1. Draw the head, nose, and large eyes, the ears, and facial pattern.

2. Draw the feet facing in four different directions.

3. Draw the spread-out body and a flat tail.

squirrels

they gather great amounts of nuts to have them available through the autumn and winter months, but sometimes they forget where they've stored them.

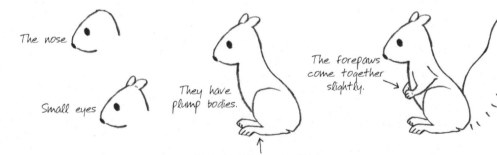

The nose

Small eyes

They have plump bodies.

Their hind legs are thick

The forepaws come together slightly.

1. Draw the nose, the head, and the eyes, and the ears.

2. Draw the body and hind legs.

3. Draw the forepaws and hind legs.

let's draw!

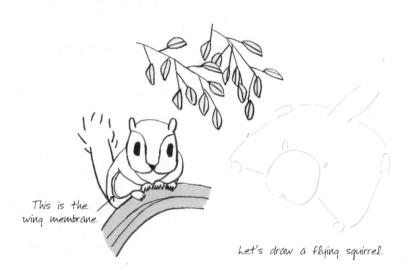

This is the wing membrane

Let's draw a flying squirrel.

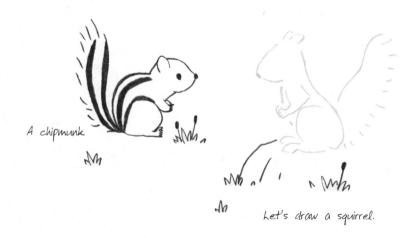

A chipmunk

Let's draw a squirrel.

rabbits

Rabbits are highly territorial and are said to prefer to be alone.

Draw the eyes at the side of the head.

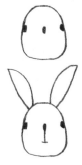

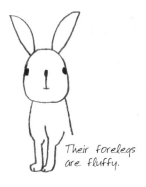

Their forelegs are fluffy.

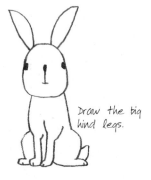

Draw the big hind legs.

1. Draw the head, nose and eyes, large ears, and a small mouth.

2. Draw the legs close together and the back.

3. Draw the large hind legs and the tail.

capybaras

The capybara is the largest animal in the rodent family. They are good swimmers and spend a lot of time in the water.

It's hard to tell the nostrils from the eyes.

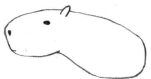

From this perspective the head looks really huge, doesn't it?

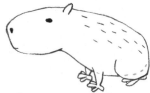

Their fingers and toes are big and partially webbed.

1. Draw a large head, the eyes, nostrils, ears, and mouth.

2. Draw a stocky body.

3. Draw the webbed feet and a bristly coat.

let's draw!

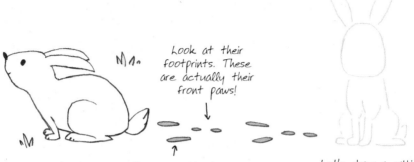

Look at their footprints. These are actually their front paws!

These are the hind paws

Let's draw a rabbit.

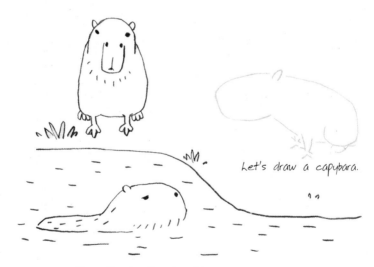

Let's draw a capybara.

They live by the riverside

to render a pose, start with the skeleton

With their long necks and noses, wings or tails, animals' poses can be quite unique and interesting. Getting a general idea of their skeletal structures and the positions of their joints can give you hints as to the poses they assume.

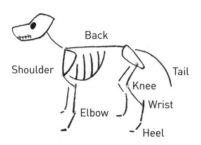

Back

Shoulder

Tail

Knee

Elbow

Wrist

Heel

Do you think this is how a dog's bones look?

Their long noses are made solely of cartilage and contain no bones at all.

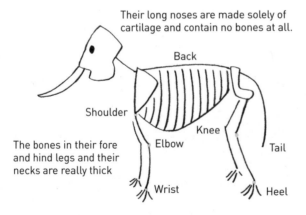

Back

Shoulder

Knee

The bones in their fore and hind legs and their necks are really thick

Elbow

Tail

Wrist

Heel

Do you think this is how an elephant's bones look?

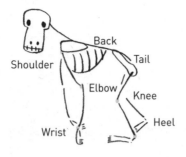

Do you think this is how a monkey's bones look?

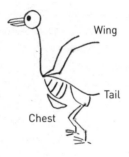

Do you think this is how a bird's bones look?

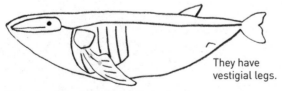
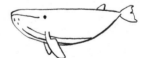

They have vestigial legs.

Their chest fins have bones that extend from their shoulders to their fingers

Do you think this is how a whale's bones look?

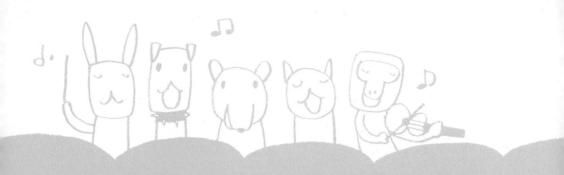

chapter 2 the wild kingdom

lions (male) / lions (female)

tigers / cheetahs

giraffes

African elephants

white rhinoceroses / hippopotamuses

ostriches / flamingoes

alligators / king cobras

anteaters / zebras

lions (male)

Male lions have gorgeous manes and protect their prides from outside intruders, but they rarely hunt.

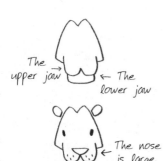

The upper jaw → ← The lower jaw

← The nose is large.

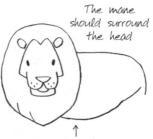

The mane should surround the head

↑ The chest hangs low and the buttocks rides high.

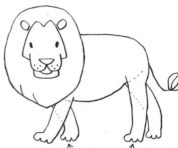

The paws are indeed catlike.

1. Draw the head, upper and lower jaws, the eyes, ears and mouth, and a big nose.

2. Draw the face surrounded by the mane and a stout body.

3. Draw thick legs and the tail.

lions (female)

The female lions hunt and take care of their cubs together. They leave the pride to give birth.

The lips are shut tight.

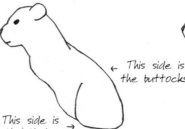

This side is the thighs. →

← This side is the buttocks.

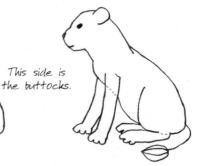

1. Draw a thick neck and head, the eyes, nose, mouth, and ears.

2. Draw a slim body and large thighs.

3. Draw the thick legs and the tail.

let's draw!

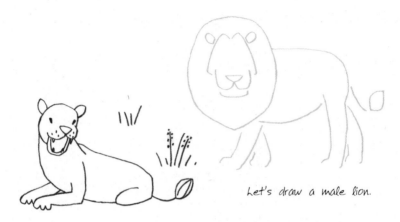

Let's draw a male lion.

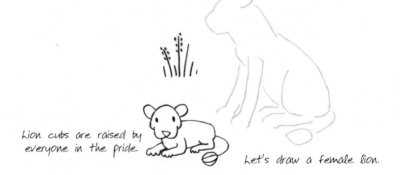

Lion cubs are raised by everyone in the pride.

Let's draw a female lion.

tigers

*A tiger will lay in wait,
carefully stalking its prey, but its success rate is rather low.*

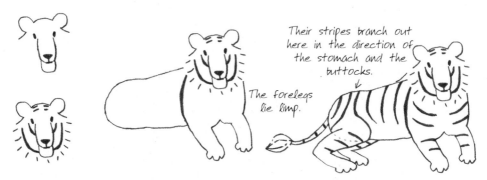

Their stripes branch out here in the direction of the stomach and the buttocks.

The forelegs lie limp.

1. Draw the head, nose and chin, the eyes and tiger pattern, and a luxuriant profile.

2. Draw the forelegs large and extending forward, and a huge body.

3. Draw the thick legs and the tail and add the tiger stripes.

cheetahs

*recording top speeds of 68 mph (110 kmh),
these are the fastest animals on Earth.*

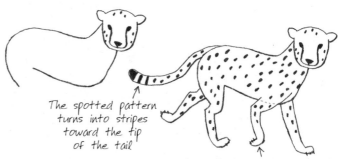

The bags under its eyes are its trademark (a trait that sets it apart from the leopard).

The spotted pattern turns into stripes toward the tip of the tail

Its nails are always exposed.

1. Draw the head, eyes and ears, the bags under the eyes and the nose, and the spots.

2. Draw a slim body and buttocks.

3. Draw the paws that kick lightly at the ground and the tail.

let's draw!

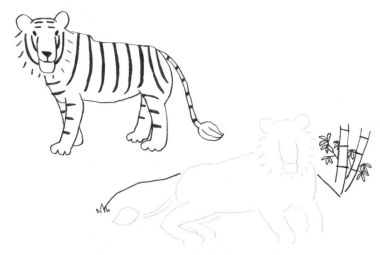

Let's draw a tiger.

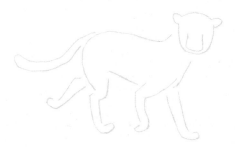

Let's draw a cheetah.

Cheetah cubs have fluffy, furry faces.

giraffes

The giraffe is the tallest animal in the world. Its blood pressure is extremely high so as to facilitate sending blood to its head.

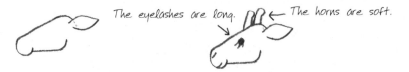

The eyelashes are long. The horns are soft.

1. Draw the head, nose and ears, the eyelashes, and horns.

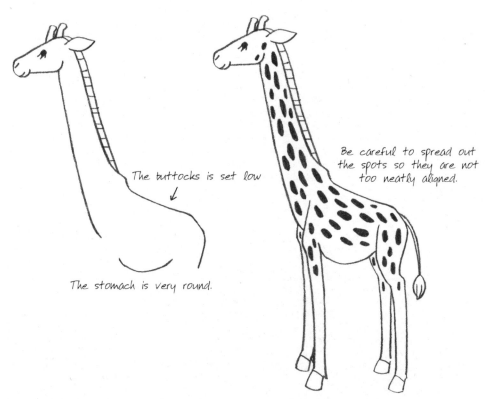

The buttocks is set low

The stomach is very round.

Be careful to spread out the spots so they are not too neatly aligned.

2. Draw the long neck and mane and the body that supports them.

3. Draw the long, slim legs and hoofs, the tail, and spots.

let's draw!

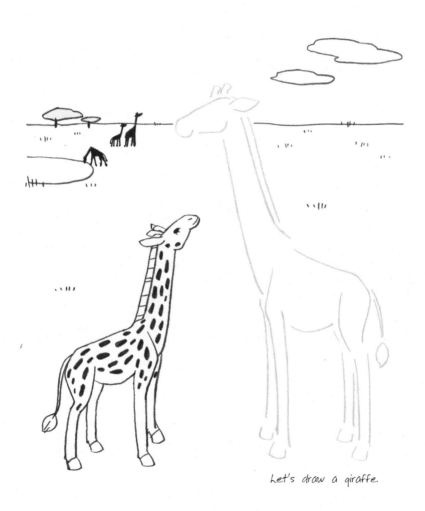

Let's draw a giraffe.

African elephants

The elephant is the largest animal in the world.
Its dexterous nose can act as both a shower and a snorkel.

The upper and lower protrusions at the tip of its nose allows it to grip things.

Tusks grow from the base of its nose.

1. Draw the head, the long nose, the eyes, large ears, and tusks.

2. Draw the large back, buttocks and stomach.

3. Draw the large, sturdy legs and nails and the tail.

Their forepaws have four nails and the hind paws have three.

let's draw!

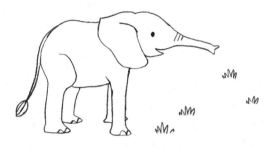

The African elephant has large ears.

Asian elephants have jutting foreheads and small ears.

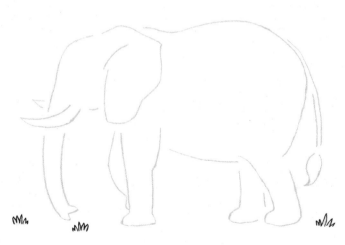

Let's draw an African elephant.

white rhinoceroses

It is said that it owes its name to the fact that someone mistakenly described its mouth as "white," rather than "wide."

Some rhinoceroses have only one horn.

The back is rugged, much like a mountain range.

Its skin is like armor.

Its mouth is flat.

The ears stand up.

This is its nose.

1. Draw the square head and two horns, the eyes, mouth, nostrils, and erect ears.

2. Draw a rugged and heavy-looking body up to the base of the legs.

2. Draw the thick legs and nails and the tail.

hippopotamuses

The hippopotamus lives its life almost entirely underwater. It can apparently open and close off its nostrils and ear openings at will.

This is the head.

This is the nose.

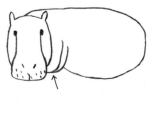

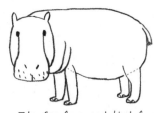

Its forelegs and hind legs are slim and the tail is short.

1. Draw the head, eyes, nose and ears, and the pores around the mouth.

2. Draw a wrinkly neck, and a large round body.

3. Draw the slim legs and the tail.

let's draw!

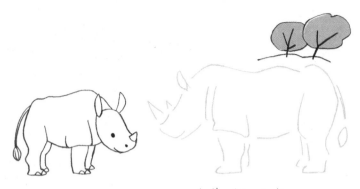

Let's draw a rhinoceros.

Let's draw a hippopotamus.

Its ears, eyes, and nose are situated on the top of its head for fast access to the surface of the water.

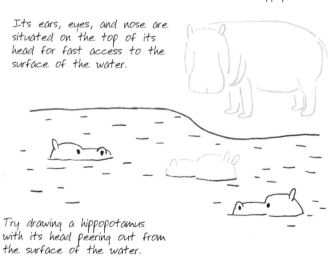

Try drawing a hippopotamus with its head peering out from the surface of the water.

ostriches

The world's largest birds, ostriches cannot fly
but they can run extremely fast.

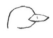

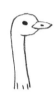

The tail feathers
↓

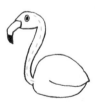

←The body's color
scheme changes
from this point.

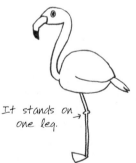

The feathers grow
in a multitude of
layers.

1. Draw the head, the
bill, the eyes, and the
long neck.

2. Draw a large round
body and the tail feathers.

3. Draw the long legs
and the feathers.

flamingoes

the reason they stand on one leg near water
is to avoid losing body heat.

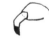

Only the tip of
the bill is black

The neck curves in
an S-like shape

It stands on
one leg.

1. Draw the head, the
curved bill, eyes, and
the long neck.

2. Draw a round body and
the wings.

3. Draw the slim legs
and the tail feathers. It
will look more like a bird
if you also draw
the leg joints.

let's draw!

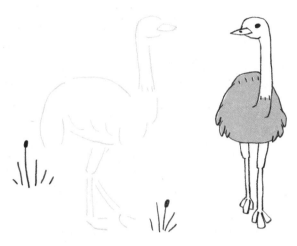

Let's draw an ostrich.

The male is black and the female is brownish in color.

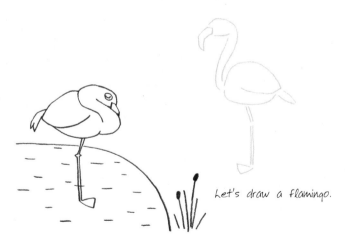

Let's draw a flamingo.

alligators

The alligator's teeth are all sharply pointed and grow back as soon as they fall out, so they are always new.

The upper jaw.

The lower jaw.

The stomach is rounded.

Spiny protrusions adorn the back in two rows.

The toes of their fore and hind legs face outward.

1. Draw the jaws and face, the eyes, nose, and sharp teeth.

2. Draw the long body and the tail.

3. Draw the legs and the horny back.

king cobras

the king cobra can inject huge amounts of poison in a single bite, enough to kill a large elephant.

Is this the shoulder?

Draw the first coil.

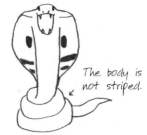

The body is not striped.

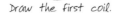

Draw as many coils as you want.

1. Draw the forehead and mouth, the eyes, nose, and sharp fangs.

2. Draw an intimidating, broadly spread hooded body.

3. Draw the coiled body and tail.

let's draw!

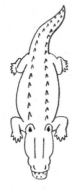

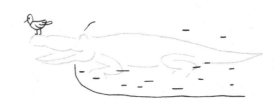

Let's draw an alligator.

It has a pattern on the back of its hood as well.

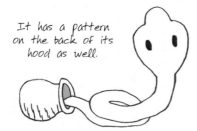

Let's draw a king cobra.

anteaters

They smash anthills and use their long tongues to quickly scoop out and eat the ants inside (at a rate of about 150 times per minute!).

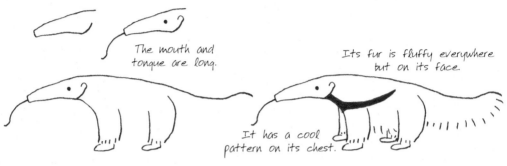

The mouth and tongue are long.

Its fur is fluffy everywhere but on its face.

It has a cool pattern on its chest.

1. Draw the long nose, and the eyes, ears, and tongue.

2. Draw a curving line all the way to the tip of the tail, then draw the legs.

3. Draw the fluffy fur and the legs on the other side.

zebras

most zebras have black stripes on a white body, but sometimes you will find zebras with white stripes on a black body.

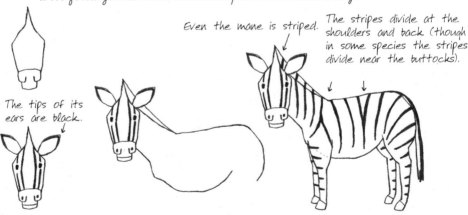

Even the mane is striped.

The stripes divide at the shoulders and back (though in some species the stripes divide near the buttocks).

The tips of its ears are black.

1. Draw the pointed forehead and the nose, and the eyes, ears, and zebra pattern.

2. Draw the neck, back, buttocks, and stomach.

3. Once you've drawn the legs and hoofs, the long tail and the striped pattern, you are done!

let's draw!

They carry their young
on their backs.

Let's draw an anteater.

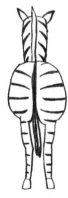

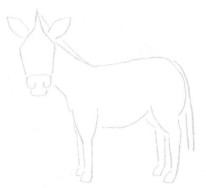

The pattern on its
buttocks looks like this.

Let's draw a zebra.

which animal made these footprints?

Horses, rhinoceroses, and so on leave odd-number hoof prints, while the hoof prints of cows, pigs, and the like are even-numbered. There are also animal prints like that of the monkey, which has fingers, and the duck, which has webbed feet.

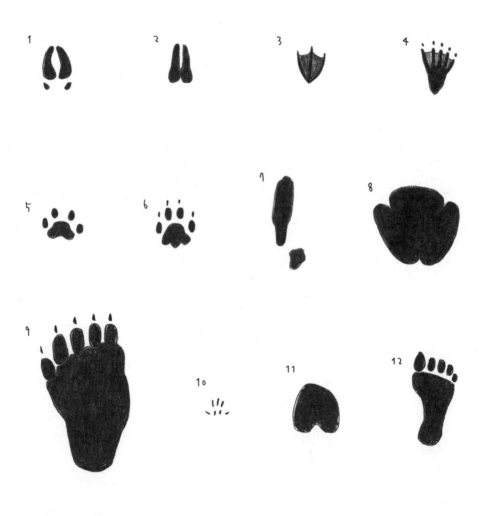

Quiz: Choose the animal that made the footprints on the previous page.

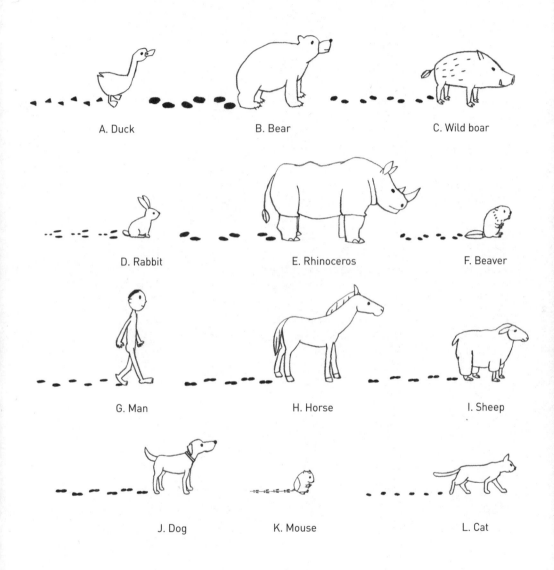

A. Duck

B. Bear

C. Wild boar

D. Rabbit

E. Rhinoceros

F. Beaver

G. Man

H. Horse

I. Sheep

J. Dog

K. Mouse

L. Cat

Answers: A(3) B(9) C(1) D(7) E (8) F(4) G(12) H(11) I(2) J(6) K(10) L(5)

chapter 3 underwater habitats

ocean and river-dwelling animals require clean water

whales

dolphins / killer whales

emperor penguins / Adelie penguins

sea lions / seals

pelicans / seagulls

beavers / otters

giant tortoises / crabs

humpback whales

Its long pectoral fins are actually transformed from what used to be legs. It is well-known for its melodious whale song.

Its eyes are situated at the end of its mouth.

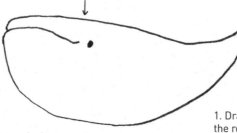

Draw a stomach large and round.

1. Draw the expansive back, the round stomach, the eyes, and mouth.

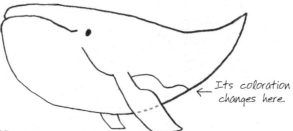

Its coloration changes here.

2. Draw the long pectoral fins and the line separating its body color pattern.

Its large oarlike pectoral fins are its trademark.

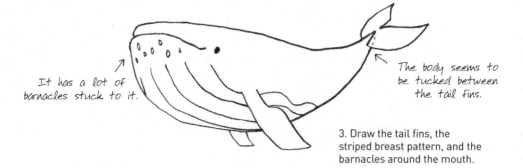

It has a lot of barnacles stuck to it.

The body seems to be tucked between the tail fins.

3. Draw the tail fins, the striped breast pattern, and the barnacles around the mouth.

let's draw!

Spouting is the way they breathe.

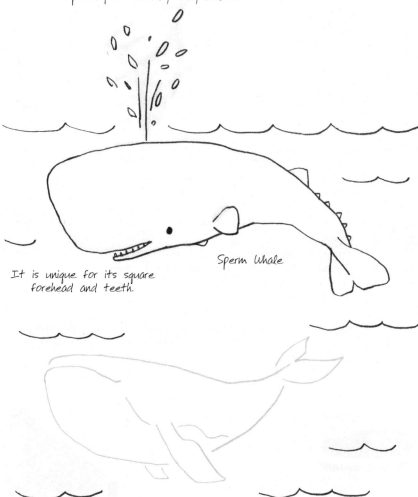

Sperm Whale

It is unique for its square
forehead and teeth.

Let's draw a humpback whale.

dolphins

*Since they can rest the left and right sides of their brains at will,
they can swim and sleep at the same time.*

 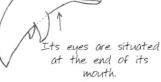 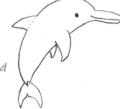

The body line is
slim and sharp.

Its eyes are situated
at the end of its
mouth.

1. Draw the nose and
the smooth body.

2. Draw the mouth
and eyes, and the
pectoral fins.

3. Draw the back
and tail fins.

killer whales

*though this ferocious carnivore will attack large sharks,
it seems they will rarely attack humans.*

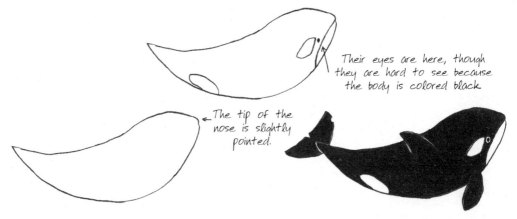

Their eyes are here, though
they are hard to see because
the body is colored black

The tip of the
nose is slightly
pointed.

1. Draw the pointed nose
and a large body.

2. Draw the mouth, the lines
separating the body pattern,
and the small eyes.

3. Draw the breast, dorsal,
and tail fins, and color in the
black areas.

let's draw!

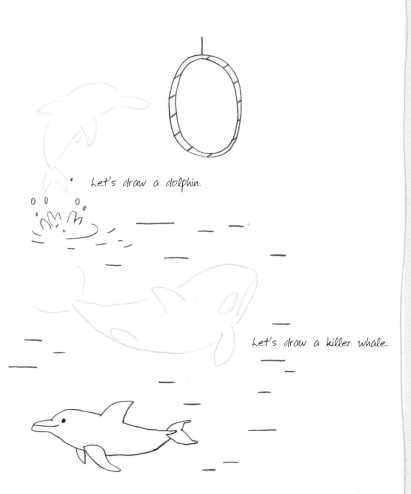

Let's draw a dolphin.

Let's draw a killer whale.

emperor penguins

At heights of up to 51 inches (130 cm), these penguins are the biggest of their kind. They have a yellow pattern on their necks.

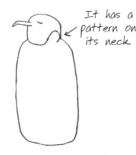

It has a pattern on its neck

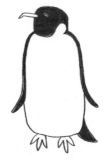

The tips of their bills are curved downward.

1. Draw the head and eyes, and a bill that curves downward at its tip.

2. Draw the large, squat body and the body pattern.

3. Draw the wings, feet, and tail feathers, and then color in the black portion of the body pattern.

Adelie penguins

These small penguins grow to heights of about 23 inches (58 cm). They have long tail feathers and pink feet.

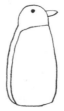

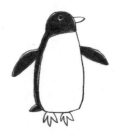

The lower part of their bodies is larger than the upper part.

1. Draw the head, the eyes, and the bill.

2. Draw a small, squat body and the body pattern.

3. Draw the wings, feet and tail feathers, and then color in the black portion of the body pattern.

let's draw!

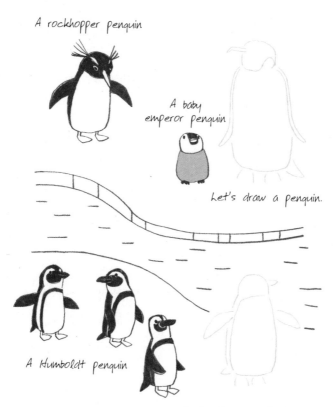

A rockhopper penguin

A baby
emperor penguin

Let's draw a penguin.

A Humboldt penguin

Let's draw an Adelie penguin.

sea lions

*Sea lions swim by flapping their forelegs like a bird.
on land they can run using all four legs.*

Sea lions have auricles (as opposed
to ear openings, which seals have).

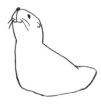

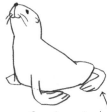

Sea lions tuck their hind
fins under their bodies.

1. Draw the head, nose, eyes,
ears, mouth, and whiskers.

2. Draw a slick body.

3. Draw the finned feet.

seals

*Seals swim by paddling their hind legs like a fish. they move about
on land by crawling like a caterpillar.*

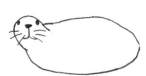

Their bodies are round and endowed
with copious amounts of fat.

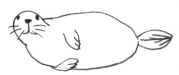

Their forefins are clawed.

1. Draw the head, eyes, nose,
mouth, and whiskers.

2. Draw a round body.

3. Draw the finned feet.

let's draw!

Sea lions are sometimes referred to as "seals with ears" or "walking seals."

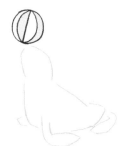

Let's draw a sea lion.

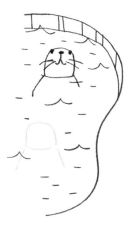

Let's draw a seal.

seagulls

Contrary to their appearance, seagulls can be quite vicious, and they are known to target not only fish, but also the baby chicks of other birds.

The tips of their bills are just slightly red. The body is plump.

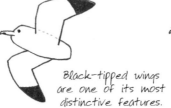

Black-tipped wings are one of its most distinctive features.

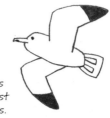

1. Draw the body, the eyes, and the bill.

2. Draw the wings and the wing tip pattern.

3. Draw the tail feathers and legs.

pelicans

Pelicans catch fish with their enormous beaks. The thing traveling the length of the tip of the lower bill to the throat is like a pouch.

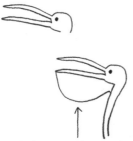

It has a pouch traveling the length of the bill from the tip of the lower bill to the throat.

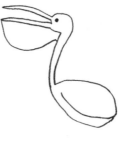

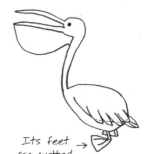

Its feet are webbed.

1. Draw the head and a pouch traveling the length of the bill from the tip of the lower bill to the throat.

2. Draw the body and wings.

3. Draw the feathers and the webbed feet.

let's draw!

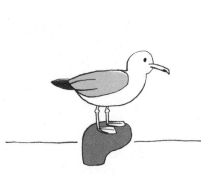

Let's draw a seagull.

It doesn't enter the water very often.

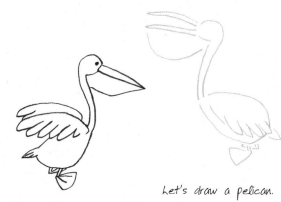

Let's draw a pelican.

beavers

Beavers build huge dams in the vicinity of their nests, using tree branches and mud. They enter their nests from underwater entrances.

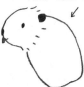

Their ears are black

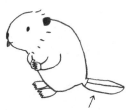

They have buck teeth.

They have slightly slouching postures.

Their tails are flat and act as a rudder.

1. Draw the head and nose, the eyes and ears, and their buck teeth.

2. Compared with the body, the head is quite large.

3. Draw the forepaws, hind legs, and the tail.

otters

Otters create a blanket out of seaweed by wrapping it around their bodies when they sleep. Their babies sleep on their mothers' stomachs.

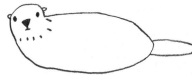

A shell looks like this.

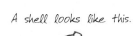

It lies on its back, with only its neck raised.

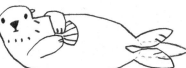

1. Draw the head and nose, the eyes and ears, and the mouth.

2. Draw a lazy body and tail.

3. Draw the hands and feet and a shell.

let's draw!

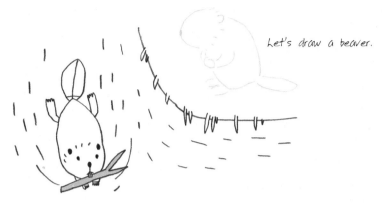

Let's draw a beaver.

Its nostrils close off underwater.

Beavers are river-dwellers,
and otters live in the ocean.

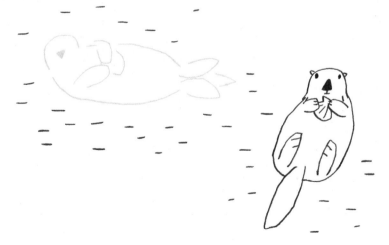

Let's draw an otter.

giant tortoises

Famous for their longevity, they can live more than 100 years because their cells metabolize so slowly.

Start by drawing half of the hexagonal shapes

The shell is like a helmet.

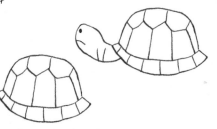

Draw a line extending from the peaks of each hexagon.

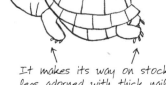

It makes its way on stocky legs adorned with thick nails.

1. Draw the shell and its pattern.

2. Add a head poking out from under the shell, then draw the eyes and mouth.

3. Draw the thick legs and nails and the stomach.

crabs

Crabs use their pincers to grab their prey, intimidate their enemies, to hide behind, and to romance potential partners. Their claws are very busy, indeed.

Their pincers bend in two places.

Their claws are comprised of a large and a small pincer.

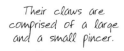

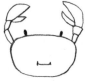

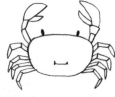

The tops of their bodies form a trapezoidal shape.

They have four legs on each side of their bodies.

1.Draw the body and eyes, and the dorsal wrinkles that look like a mouth.

2. Draw pincers that bend in two places.

3. Draw their eight legs.

let's draw!

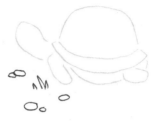

Let's draw a giant tortoise.

Let's draw a crab.

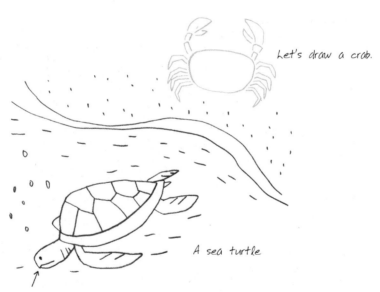

A sea turtle

The tip of its mouth
is pointed downward.

The shape of the sea turtle's shell
is not affected by water resistance.

comparing animal sizes

Though measuring the size of animals can be complicated and difficult, let's try comparing their average sizes. The fact that animals of so many different sizes can live together on the Earth is rather intriguing.

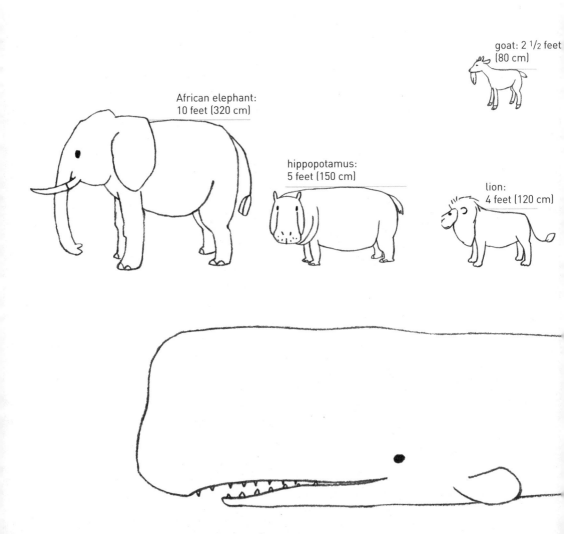

goat: 2 1/2 feet (80 cm)

African elephant: 10 feet (320 cm)

hippopotamus: 5 feet (150 cm)

lion: 4 feet (120 cm)

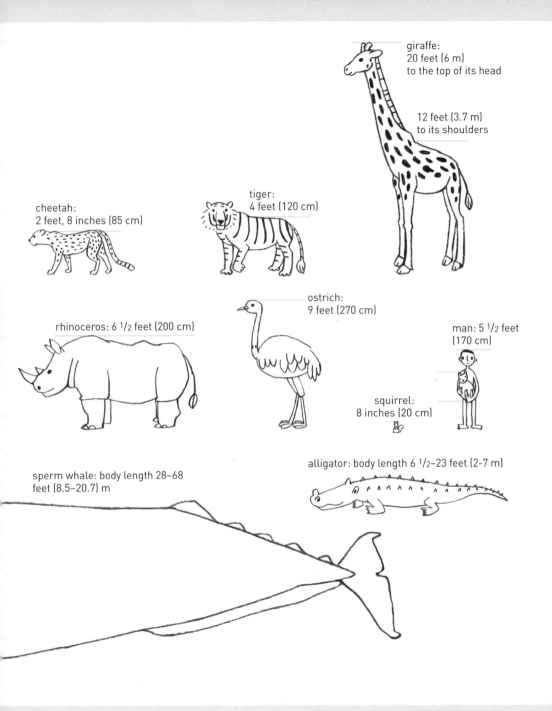

giraffe:
20 feet (6 m)
to the top of its head

12 feet (3.7 m)
to its shoulders

tiger:
4 feet (120 cm)

cheetah:
2 feet, 8 inches (85 cm)

ostrich:
9 feet (270 cm)

rhinoceros: 6 ½ feet (200 cm)

man: 5 ½ feet
(170 cm)

squirrel:
8 inches (20 cm)

sperm whale: body length 28–68
feet (8.5–20.7) m

alligator: body length 6 ½–23 feet (2-7 m)

chapter 4 we are friends

animals who live as part of
the family love their families, too

miniature dachshunds / toy poodles

golden retrievers / dalmatians

Persian cats / Japanese cats

guinea pigs / hamsters

budgerigars / cockatiels

miniature dachshunds

It is said that their legs grow short to give them easier access to badger nests.

The nose and the
forehead

The ears and
jaws

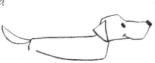

Draw the legs half as long
as you think they are.

Draw the body twice as
long as you think it is.

1. Draw the head, nose
and eyes, and the ears
and jaws.

2. Draw the lengthy
body and the tail.

3. Drawn the cute,
short legs.

toy poodles

these extremely smart dogs enjoy learning new things.

The nose and
forehead

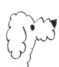

The ears
and neck

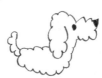

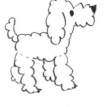

Draw a solid mass of fur keeping
in mind the shape of the body.

1. Draw the head, nose
eyes, ears, and neck.

2. Draw a body with a
thick mass of fur.

3. Draw the legs and
dainty claws.

let's draw!

A pug A yorkshire terrier

A chihuahua A Boston terrier

Let's draw a miniature dachshund.

Let's draw a toy poodle.

golden retrievers

These gentle dogs have powerful bodies and a strong sense of family.

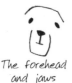

The forehead
and jaws

Draw luxuriant fur
on the chest and,
oddly enough, the
entire body seems
luxuriant.

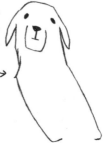

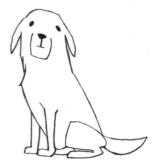

1.Draw the large head,
droopy ears, and thick
neck.

2. Draw the hefty
chest and back.

3. Draw the stout legs
and thick tail.

dalmatians

Long ago, dalmatians used to run alongside horses,
protecting horse-drawn carriages from thieves.

The base of
the ears rests
slightly below
the head.

The body becomes slimmer
the closer it comes to
the buttocks.

The shape of the legs would look like
this if compared to a man's legs.

The knee

The heel

1. Draw the large head,
pointed nose, the droopy
ears, and the neck.

3. Draw the long legs, a
svelte tail, and the spots.

2. Draw the sleek, muscular body, and a collar.

let's draw!

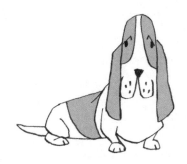

A basset hound

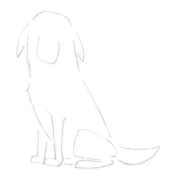

Let's draw a golden retriever.

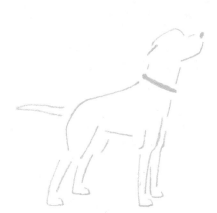

Let's draw a dalmatian.

A Japanese dog

Persian cats

Their long-haired coats and flat noses are their most outstanding features. They like to passively observe their surroundings.

The eyes are situated at the same height as the nose. ←

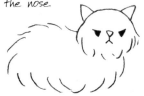

Draw luxuriant fur, keeping the shape of the body in mind.

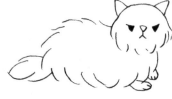

1. Draw the wide head, the flat nose, and the ears.

2. Draw the round body with a luxuriant coat.

3. Draw the slightly aligned forepaws and the thick tail.

Japanese cats

Short-tailed cats are rare, and striped, dappled, and calico cats are unique.

Their paws gather together in one place.

1. Draw the face and the nose with a clearly formed bridge, the ears, and a small nose.

2. Draw the well-developed forelegs standing slightly close to each other.

3. Draw the rounded back, the hind legs peering out from the sides of the forepaws, and the short round tail.

let's draw!

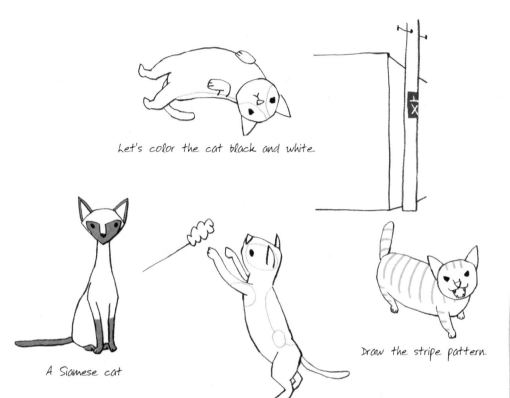

Let's color the cat black and white.

A Siamese cat

Draw the dapples of a calico cat.

Draw the stripe pattern.

Let's draw a Persian cat.

Let's draw a Japanese cat.

guinea pigs

The lazily moving guinea pig is an easy-going creature.
It expresses its emotions through its cries.

Their ears are wrinkly.

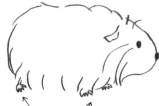

Draw luxuriant fur, keeping the shape of the body in mind.

The fore and hind legs are small.

1. Draw the round, hairy profile and the ears.

2. Draw the round body with a luxuriant coat. It doesn't have a tail.

3. Draw the small forepaws and hind legs.

hamsters

Hamsters hoard food into their cheek pouches. They are extremely good at using their forepaws.

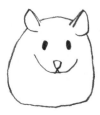

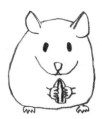

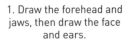

The eyes are droopy.

1. Draw the forehead and jaws, then draw the face and ears.

2. Draw a round body like a rice ball.

3. Place a sunflower seed in its small hands, then draw the small feet.

let's draw!

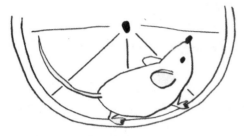

A small hamster

A Roborovskii hamster

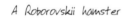

Let's draw a quinea pig.

A house mouse

Let's draw a hamster.

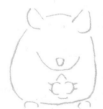

A rat

budgerigars

These birds are very friendly and some even talk.

The beak seems to be immersed in the head. The color of their feathers changes at this point.

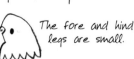

The fore and hind legs are small.

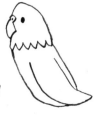

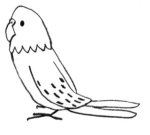

1. Draw the profile with its protruding forehead, the beak, and the round eyes.

2. Draw a winged body that could fit perfectly in the palm of your hand.

3. Draw its luxuriant tail feathers and slim legs.

cockatiels

The cockatiel, with its charming and elegant crests and cheeks, is actually a cousin to the parrot.

The decorative crest feathers and the apple cheeks are its most charming points.

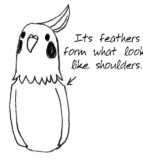

Its feathers form what looks like shoulders.

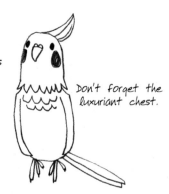

Don't forget the luxuriant chest.

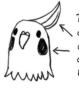

1. Draw the head, the beak, the cheeks, and the crest.

2. Draw the body and wings.

3. Draw the tail feathers and the feet with small claws.

let's draw!

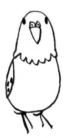

A Java sparrow

An African Gray parrot

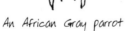

Let's draw a budgerigar.

Let's draw a cockatiel.

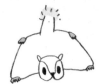

epilogue gallery

Now let's try coloring these illustrations in you favorite colors. The colors you choose don't have to be the actual colors of the animals!

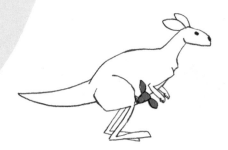

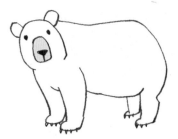

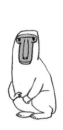

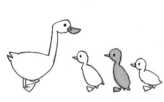

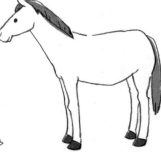

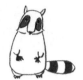
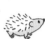

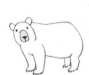
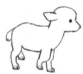
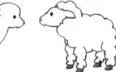
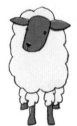
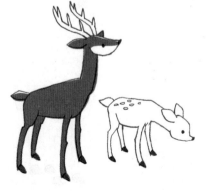
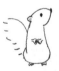
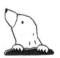

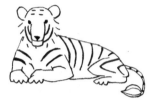

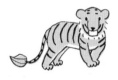

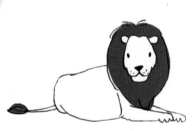

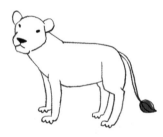

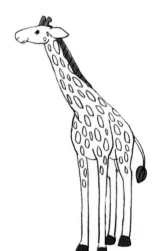

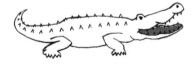

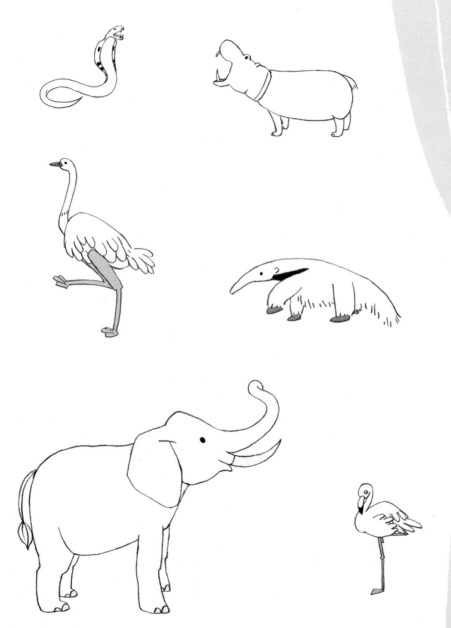

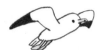

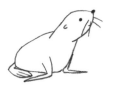

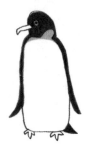

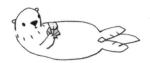

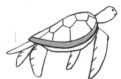

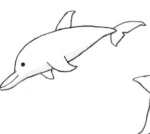

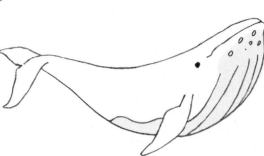

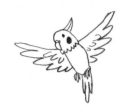
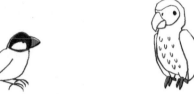
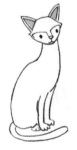
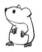
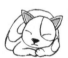
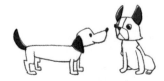
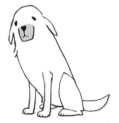

about the author

Sachiko Umoto graduated with a degree in oil painting from Tama Art University in Tokyo, Japan. In addition to her work as an illustrator, she also produces animation for USAGI·OU Inc. She is the author of *Illustration School: Let's Draw Happy People* and *Illustration School: Let's Draw Plants and Small Creatures* (both originally published in Japan by BNN, Inc.). She dearly loves dogs and Hawaii.

 Visit her online at http://umotosachiko.com.